World Heritage
Hildesheim Cathedral and its Treasures

Claudia Höhl, Michael Brandt,
Karl Bernhard Kruse, Thomas Scharf-Wrede

World Heritage
Hildesheim Cathedral and its Treasures

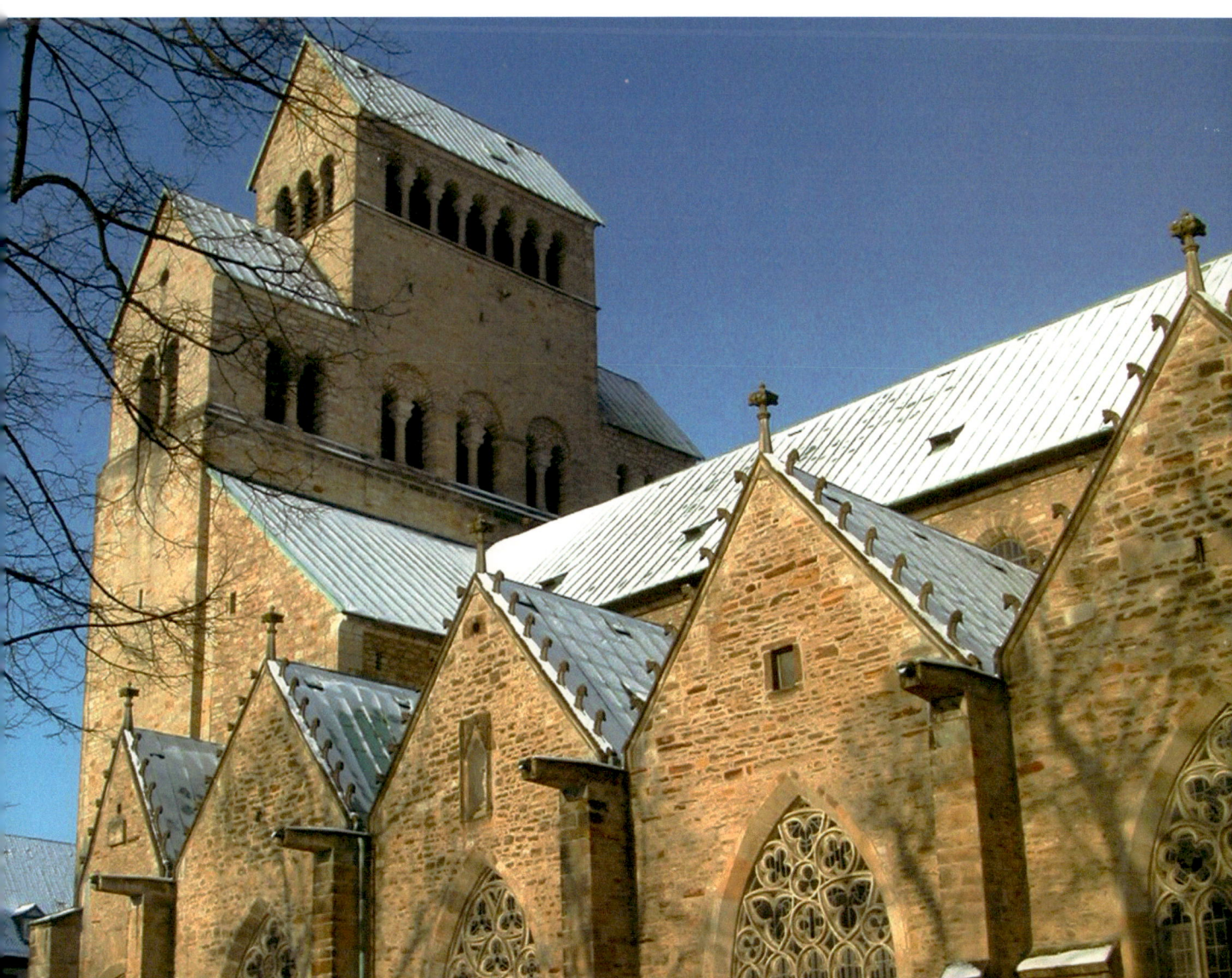

Translation: Michael Wolfson

Imprint
© 2007 Bernward Media Corporation in cooperation with Schnell & Steiner Publishing Corporation
Layout and production: Bernward Media Corporation
Print: Druckhaus Köhler, Harsum

ISBN-13: 978-3-7954-2003-1

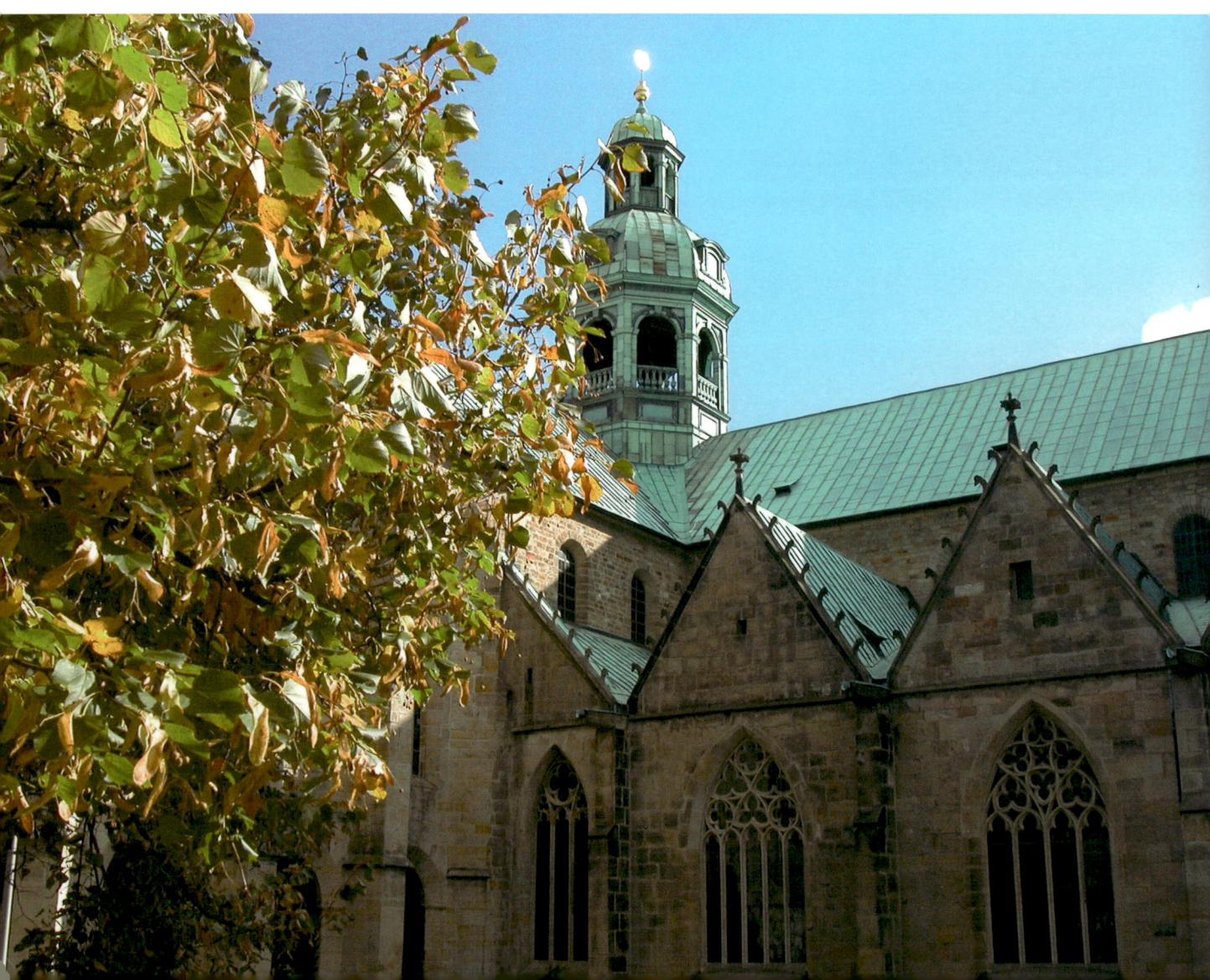

Contents

4 MICHAEL BRANDT, CLAUDIA HÖHL
 St Mary's Cathedral in Hildesheim and its Artworks

13 THOMAS SCHARF-WREDE
 The Architecture – a Chronological Overview

22 KARL BERNHARD KRUSE
 The Architectural History of Hildesheim Cathedral

40 Illustrations

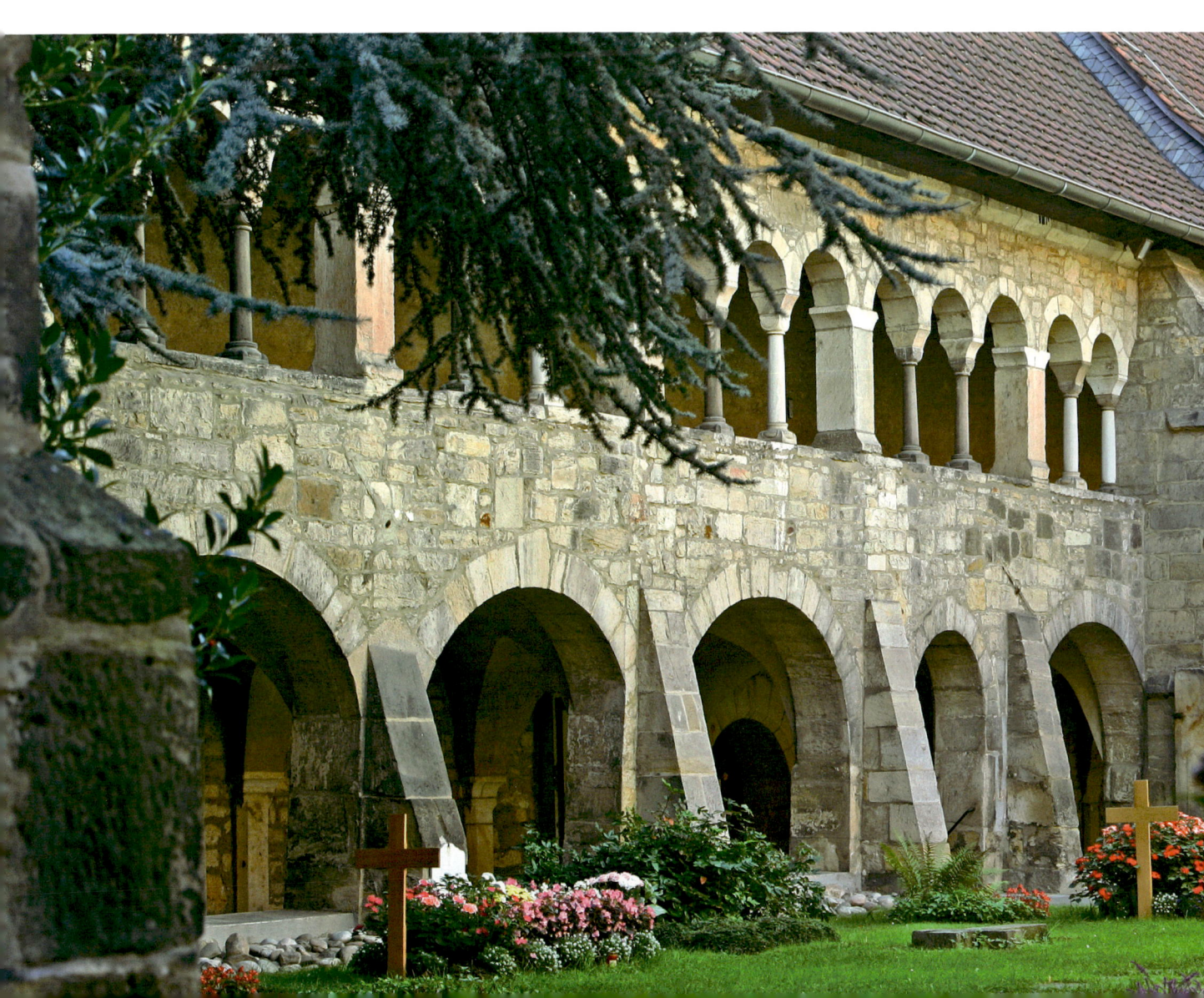

MICHAEL BRANDT,
CLAUDIA HÖHL

St Mary's Cathedral in Hildesheim and its Artworks

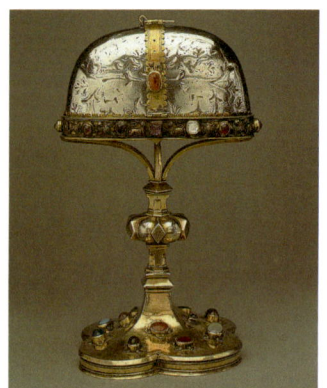

Foundation Reliquary.

Transfer to Bishop Norbert Trelle on 11 February 2006.

Apse with Thousand-Year-Old Rosebush and the Foundation Reliquary, from: Johann Ludwig Brandes, Gloriosa Antiquitas Hildesina, Hildesheim 1724 (detail).

The fact that Hildesheim Cathedral was entered on the UNESCO World Cultural Heritage list in spite of the severe wartime damages it suffered is largely due to its many historical artworks. Along with St Michael's, the cathedral provides „the most comprehensive and immediate access to the understanding of how Romanesque churches in the Latin West were decorated". However, these „decorations" do not solely refer to the permanently installed works in the church, but also the reliquaries, liturgical vestments and „Vasa sacra" belonging to the cathedral treasury as well. They still play an integral liturgical part in the cathedral today. Not only do they provide information about past times, they also document the unbroken vitality of the ecclesiastical tradition.

The cathedral's central sacrosanct object is the silver reliquary of the Virgin presented by Louis the Pious to the first bishop Gunthar when the diocese was founded in 815. A note in the medieval records of the cathedral chapter describes its contents including particles of the Virgin's robe and her hair as well as Christ's sudarium. The reliquary's contents and its artistic design suggest that it originally belonged to the Carolingian ruling family, probably to Charlemagne himself. The history of the diocese's founding, the earliest version of which stems from the eleventh century, says that Louis crossed the Leine on his way from Elze during a hunting trip and had the Holy Mass celebrated at the site of the present-day cathedral in the shadow of a tree. Relics of the Virgin from the court chapel were taken along, but then forgotten here. The anxious imperial chaplain left Elze to retrieve them and succeeded in finding them. Despite all his physical exertions, he was not able to remove the relics of the Virgin from the tree on which they had hung the previous day. The Emperor returned to the spot and interpreted this as an sign of divine will, indicating that the Virgin wished that a chapel be erected here

as soon as possible and that the church in Hildesheim be granted episcopal rank instead of Elze. The reliquary of the Virgin Mary and the rosebush that has been identified with the ‚tree' mentioned in the „Fundatio" legend since the seventeenth century still serve of reminders of the cathedral's and the diocese's beginnings as well as identifying symbols of Hildesheim's church.

Architectural elements dating back to the Carolingian cathedral church erected during the episcopate of Bishop Altfrid (851-874) can still be seen in the cathedral today. The entrances to the Carolingian crossing crypt with their figurative and colourfully decorated stucco tympanum have survived in the southern and northern transepts next to the present-day choir. Their remnants were found after the war.

Around 1000, Hildesheim developed into one of the Ottonian Empire's most important artistic centres primarily due to the activities of Bishop Bernward. Two monumental bronzes have survived in the cathedral: the doors of St Bernward and the Column of Christ from St. Michael's.

The bronze portal containing the two over 5-metre high doors each cast in one piece are among the technical masterpieces of medieval art. The pictorial programme of the left door shows Old Testament scenes from the Book of Genesis beginning with the creation of Adam at the top and the killing of Abel by his brother Cain at the bottom. The right door contrasts the fratricide with the Annunciation of Christ's birth at the bottom. This is followed from the bottom up by scenes from the childhood and Passion of Christ in addition to a depiction of the appearance of the resurrected Christ's before Mary Magdalene, providing a fascinating compilation of Christian salvation history. The pictorial sources can in part be traced to Carolingian bible illustrations, and the theologically precisely thought out sequence of images was certainly influenced by Bernward himself. Another of Bernward's famous donations, the Golden Virgin, which is among the earliest known freestanding images of the Virgin in Western Europe, was also intended for the cathedral. The wooden statue of the enthroned Virgin is bedecked with gold foil and

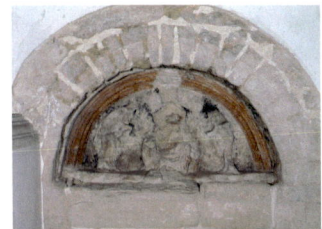

Tympanum of the entrance to the Carolingian ambulatory crypt.

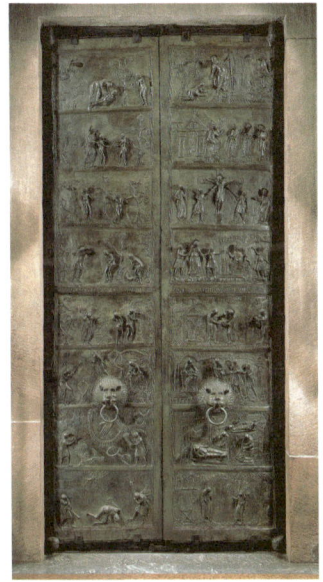

Bernward Doors, c. 1015.

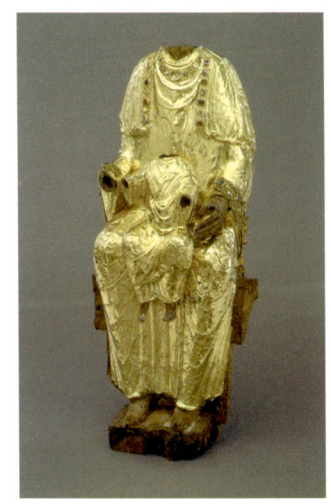

Golden Virgin.

St Mary's Cathedral in Hildesheim and its Artworks

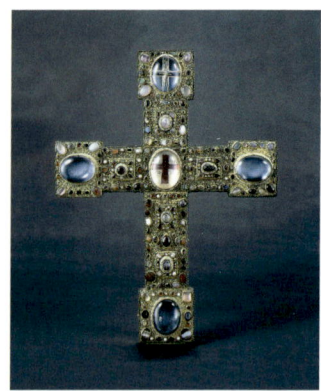

Cross of St Bernward.

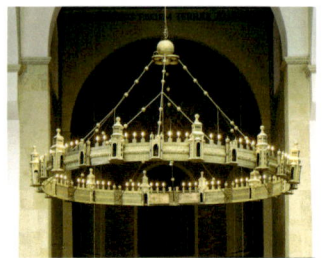

Chandelier of Bishop Hezilo, c. 1061.

embellished with bejewelled ornamental bands. A thirteenth century entry in the cathedral chapter's memorial book records a theft in which some of the jewellery was stolen. A number of the ornamental bands therefore had to be replaced. The numerous reworkings and additions made during the Baroque period, which have now been removed, in addition to the numerous votive offerings indicate the figure's importance as a statue with miraculous powers. The 1438 inventory of the cathedral treasury alone lists well over 100 chains, rings and other pieces of jewellery that had been donated to this image of the Virgin.

The wide spectrum of Bernwardian artworks and the veneration accorded to them following his canonization in 1194 are well documented in the rich collection of the cathedral treasury. Numerous items from St Michael's also found their way here, including the so-called Precious Gospels, the silver Bernward candlesticks, and the Bernward Cross.

A fire in 1046 made a reconstruction of the cathedral necessary and also presented the opportunity to refurbish and/or add to the existing decorations. Bishop Hezilo, who drove on the reconstruction work based on the surviving remnants from the earlier structure (consecration 1061), donated the famous wheel-shaped chandelier now located above the present-day high altar in the choir. The gilded copper chandelier represents the heavenly city of Jerusalem as described in the Book of Revelations, is confirmed by inscriptions on the chandelier itself. The chandelier was original intended for the nave, while a second, slightly smaller wheel-shaped chandelier donated by Hezilo's predecessor Thietmar (1044-54) was hung in the choir. This chandelier, which was comprehensively re-worked around 1400, was only recently moved to St Anthony's Church. A further decoration that can most probably also be attributed to Bishop Hezilo was the placing of a monumental candelabra at the centre of the cathedral in front of the cross altar. The almost 2-meter tall travertine shaft (a material taken from the Roman Eifel aqueduct) probably was used for the Easter candle. A crown shaped like a drip

St Mary's Cathedral in Hildesheim and its Artworks

bowl made of gilded copper has been preserved. A silver statue of the Virgin Mary has stood atop the column since 1741. It was made by Paul Jobst Syri, a Hildesheim goldsmith. The column stood in front of the stairs leading to the crossing until the end of the nineteenth century; it is now located on the gallery of the northern transept. The description identifying it as an Irminsul or Irmin's Column dates back to a seventeenth century legend that linked Charlemagne to the fall of a Saxon ritual column.

The unique eleventh century ensemble consisting of the two wheel-shaped chandeliers and the Easter candelabra can still be seen in nineteenth century depictions of the cathedral's interior.

While Hezilo's structure retained the old Carolingian apse, this section was rebuilt 100 years later. The new raised choir was lavishly decorated with a new stucco floor for example. Remnants of it, now preserved in the Cathedral Museum, reveal a carefully conceived pictorial program. Personifications of virtues as well as biblical scenes are combined in accordance with the scholastic theology of the High Middle Ages into an instructive image of the Christian cosmos.

The extensive redecoration of the cathedral that took place during the first half of the twelfth century also encompassed the two large reliquary shrines of the cathedral's patron saints known as the Epiphanius Shrine and the Gotthard Shrine. The later is stylistically related to works produced at the famous Helmershausen monastery, an important centre of early Romanesque art. The unique ensemble of three flagellums made of gilded copper with large rock crystals now preserved in the Cathedral Museum probably belonged to an altar erected during the luxuriant redecoration of the cathedral choir. Prominent donors contributed to the growth of the cathedral treasury with precious reliquaries. In 1185/86 for example, Duke Henry the Lion and his wife Mathilde donated the head reliquary of St Oswald.

Hildesheim's importance as a religious and artistic centre grew even further during the early thirteenth century. The art of bronze casting was among the artistic techniques especially cultivated here since

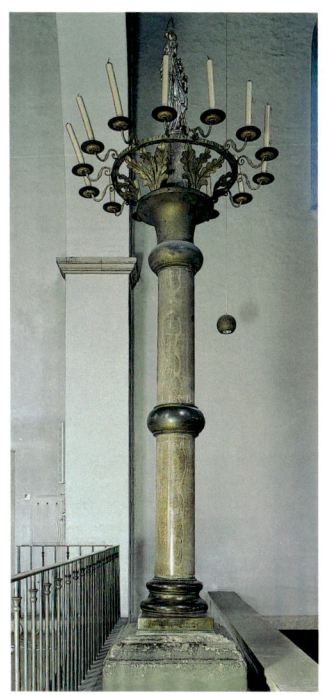

So-called Irmin's Column.

Detail of stucco floor.

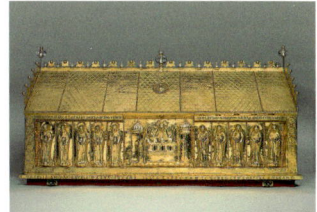

Shrine of the Cathedral's Patron Saints (so-called Epiphanius Shrine).

St Mary's Cathedral in Hildesheim and its Artworks

Flagellum.

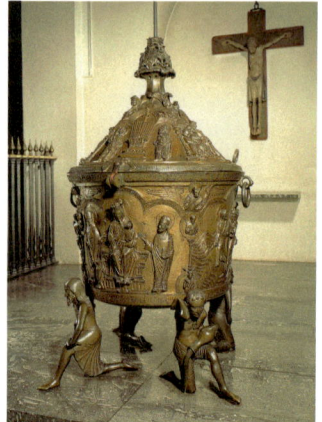
Bronze Baptismal Font.

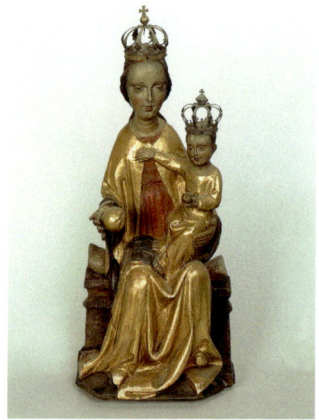
Virgin of Mercy.

the times of Bishop Bernward. Large bronzes of the highest quality were added to the cathedral's decorations around 1220/30: the baptismal font and the eagle lectern.

The baptismal font combines the images of the Virgin Mary, the cathedral's patron saint, and the donor Wilbernus with a comprehensive cycle of scenes from the Old and New Testaments dealing with the topic of baptism such as the baptism of Christ in the Jordan and the crossing of the Red Sea by the Israelites. The bronze eagle lectern - the original is now preserved in the Cathedral Museum - depicts the powerful figure of the bird of prey fighting the twisting dragon, a motif possibly stemming from Italy symbolizing the triumph over evil. Its design links naturalism and artistic stylisation.

Bishop Gerhard vom Berge was the leading figure in the political, religious, and artistic development of the diocese and the city during the fourteenth century. He succeeded in defeating the powerful Duke Magnus of Brunswick at the battle of Dinklar in 1367. The silver foundation reliquary from the ninth century, which the bishop carried with him into battle, is said to have decided it in Hildesheim's favour. The bishop spent three days and three nights in prayer pleading for the intercession of the Virgin at the altar dedicated to her in the cathedral crypt. Bishop Gerhard marked his gratitude for the victory with precious donations, financing for example the gilding of the wooden dome above the cathedral crossing from the ransom money received for the release of his prisoners. He also donated lavish liturgical items including the so-called chalice of St Bernward. The extraordinary nature of this donation is indicated by its material and artistic value. The chalice is made of pure gold and its node consists of a single cut citrine. It is also decorated with precious antique gems as well as an engraved cycle of scenes from the New Testament. The sculpture of the Virgin Mary from the crypt that is now located in a niche in the southern transept became the cathedral's central image of mercy. The richly ornamented bronze lattice also belongs to the new decorations made for the crypt at that time.

St Mary's Cathedral in Hildesheim and its Artworks

The bishops, the city's patricians, and above all powerful cathedral canons such as the wealthy Lippold von Steinberg contributed to the enlargement of the cathedral during the fifteenth century. Gothic chapels were built adjacent to the side aisles and the large new "paradise" on the north side of the cathedral formed a representative entrance. The Virgin Mary is at the centre of the sculptural program of this monumental structure. She is flanked by Saints Epiphanius and Gotthard; the later is depicted holding the Carolingian foundation reliquary as a symbol of the bishopric's divine legitimacy.

When Hildesheim became Protestant during the Reformation, the city detached itself from the Catholic prince-bishopric. The canons reacted to Johann Bugenhagen's introduction of the Reformation in Hildesheim in 1542 with several decidedly counter-reformatory artworks for the Cathedral. Cathedral canon Arnold Fridag had a large choir screen erected in 1546 in which the chancel occupies a central position, demonstrating the importance that the propagation of God's word also had in the old Catholic rites. The choir screen is now situated in St Anthony's Church. It was carved in the new stylistic language of the Renaissance in the renowned workshop of the brothers Johann and Franz Brabender from Münster. The pictorial program juxtaposes scenes from the Old and New Testaments and depicts, aside from the Passion of Christ, the Virgin Mary, before whom the kneeling donor had himself depicted.

Between 1580 and 1590 canon Ernst von Wrisberg commissioned a picture cycle for the cathedral crossing. Flanked by depictions of the Birth of Christ and the Ascension, the series of images shows the Crucifixion of Christ in the middle in conjunction with the Seven Holy Sacraments in accordance with the sacramental teachings of the Council of Trent (1545-63), and should be understood as a programmatic Catholic counter-reformatory image.

The high altar was also renewed during the early seventeenth century. The pictorial program consisting of a total of five alabaster reliefs depicting scenes from the life of the Virgin - the Meeting of Saints Joachim and Anne at the Golden Gate, the Annunciation, the

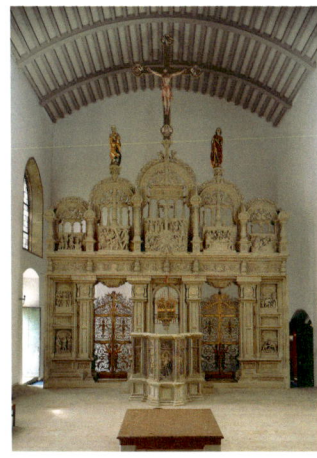

Cathedral Choir Screen, rebuilt in St Anthony's Church.

Representation of the Sacraments from the donation of the Cathedral Canon Ernst von Wrisberg (c. 1585).

St Mary's Cathedral in Hildesheim and its Artworks

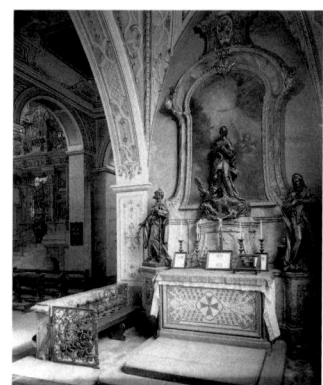

Altar of the Immaculate Conception, Paul Egell 1729-31 (pre-war photograph).

Altarpiece.

Birth of Christ, the Adoration of the Kings with the Coronation of the Virgin at the centre - again emphasize the Virgin's role as the cathedral's patron saint. Only a few fragments of the altar survived the devastating bombardment of 22 March 1945.

Not only were the walls and ceiling decorated with stucco during the baroque reconstruction of the cathedral (1718-1734) but the altars were revamped or redesigned as well. The distinguished baroque sculptor Paul Egell was commissioned by the Hildesheim Suffragan Bishop von Twickel to carve a large altar between 1729 and 1731 depicting the Immaculate Conception as a monumental group of figures with the Virgin Mary on a cloudbank accompanied by her parents Joachim and Anne.

Precious silver artworks supplemented the opulent baroque decorations in the cathedral, including the altarpiece depicting the return of the Holy Family from Egypt and a silver antependium for the high altar made in Cologne around 1700 (now in the Cathedral Museum).

Because of the secularisation of the nineteenth century, some of the artworks from St Michael's Church and its treasury also entered the cathedral treasury. These included the famous silver cross of St Bernward and the Guntbald Gospels, which were also donated by bishop Bernward (both are now in the Cathedral Museum). The treasury's growing inventory was enlarged even further by the art collection of Bishop Eduard Jakob Wedekin. His testament foresaw the founding of a diocesan museum which now also encompasses the works from the cathedral treasury.

During the nineteenth century, interest was focused primarily on the personality of Bishop Bernward. A monumental statue of the bishop was erected in the courtyard in front of the cathedral in 1893. The Berlin sculptor Karl Ferdinand Harzer created the larger-than-life statue along with three reliefs with scenes from the life of the saint for the pedestal, which are now unfortunately lost.

The Column of Christ, which also came from St Michael's church, was erected in the southern transept of the cathedral in 1895. In St

St Mary's Cathedral in Hildesheim and its Artworks

Michael's it stood near the eastern choir and was therefore in a part of the church accessible only to the monks. Its pictorial program, encompassing a selection of scenes from all four gospels, depicts central New Testament episodes from the Baptism of Christ to the Entry into Jerusalem in addition to the Death of John the Baptist as well as parables such as Dives and Lazarus. Bernward had seen the linking of a sequence of images rising in a spiral on a column on Roman imperial victory columns, for example the Trajan Column, and adapted this model as a Christian sign of victory. The column was not made to provide bible lessons to the illiterate, but to present the sum total of triumphant divine events to the world of the monastic community.

The cathedral, which was severely damaged during the war, was only re-consecrated in 1960. Fortunately, many of the older artworks were evacuated in time and could be returned to the cathedral after the war. Other objects had to be remade, including the tabernacle in the crypt, which has since been utilised as a sacramental chapel. It is a characteristic work by the Benedictine nun Lioba Munz from Fulda. The Mariological pictorial program of her large enamel applications refers to the cathedral's patron saint.

Among the most fascinating sites in the cathedral complex at Hildesheim is the cloister with the Thousand-Year-Old Rosebush that recalls the site where the cathedral and the diocese were founded. The two-storied cloister constructed during the twelfth century was fortunately spared from wartime destruction. The most impressive of the many funerary monuments is the tombstone of Bruno the Priest situated on the southern exterior wall of the choir. Its extraordinary composition and the sequence of texts exemplify the hopes for salvation through God's mercy during the Middle Ages.

The Gothic St Anne Chapel with large gargoyles shaped in the form of fantastic monsters has stood at the centre of the cloister courtyard opposite the rosebush since 1321. The tympanum relief above the entrance of this funerary chapel depicts St Anne with the Virgin Mary and the Christ Child.

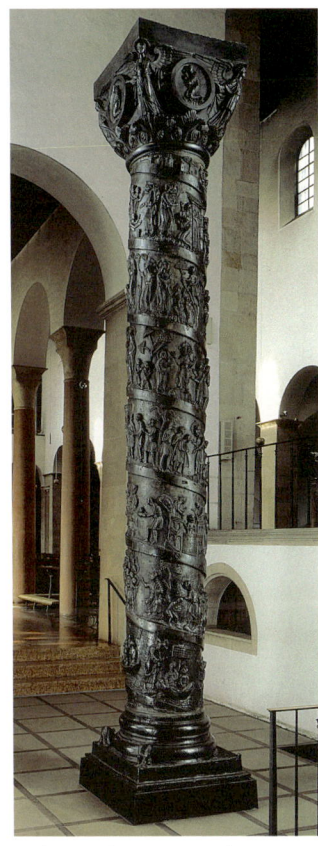

Column of St Bernward.

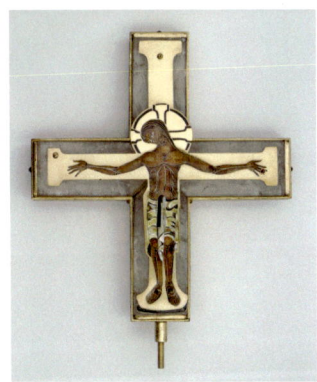

Cross from the tabernacle in the crypt.

St Mary's Cathedral in Hildesheim and its Artworks

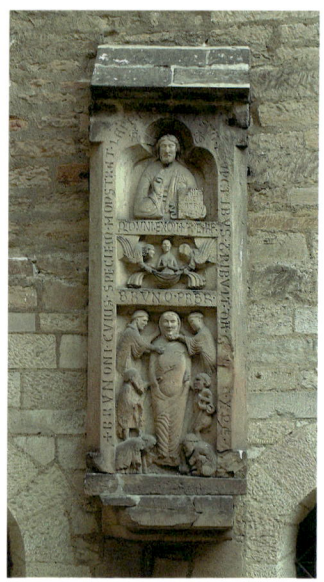

Tombstone of Bruno the Priest, late twelfth century.

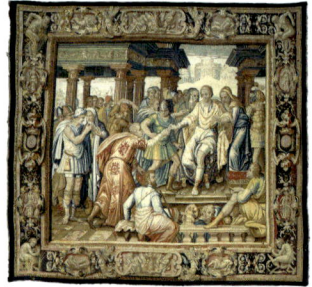

Cross from the tabernacle in the crypt.

Aside from the cloister, the St Lawrence Chapel with its richly decorated capitals is the only one of the Romanesque cathedral annexes still standing. It now serves as the cathedral sacristy and is therefore not open to the public.

Several Gothic annexes, especially the chapter house to the south, were built at the same time as the St Anne Chapel. It is now the home of the Cathedral Museum. Among the artworks from the old chapter house was the so-called Inkpot Madonna carved about 1430, which is now situated on the southern pillar adjacent to the stairs leading up to the choir. It originally stood in the chapter's meeting hall where it symbolized the admonishing presence of the diocese's and cathedral's patron saint during the consultations of the canons.

A meeting hall had been built next to the chapter house for the delegates of the prince-bishopric as early as the fifteenth century. The chapter had it redesigned as a representative ceremonial hall during the eighteenth century. The central theme of the opulent wall and ceilings frescoes, which were destroyed during the war, was the history of the diocese. A series of eight tapestries woven in Paris around 1615 had been acquired to fill the large wall surfaces. Six of them survived the ravages of World War II. The pictorial cycle depicts the legend of Artemisia who taught the virtues of the ruler to her young son. In Hildesheim, however, the pictorial program was linked to the youthful days of Louis the Pious. Like the foundation reliquary, the tapestry cycle stands for the rooting of Hildesheim's church in its 1200-year-long history.

The Architecture – a Chronological Overview

THOMAS SCHARF-WREDE

815 — Emperor Louis the Pious founded a bishopric in Hildesheim – and not in Elze as originally planned – and had a small church („sacellum") erected on the cathedral hill.
The „Fundatio Ecclesiae Hildensemensis", the oldest version of which dates from the eleventh century, presents a vivid description of the founding of the diocese Hildesheim as an indispensable act in terms of the overall Carolingian imperial and ecclesiastical policies.

c. 820 — Gunthar, the first bishop of Hildesheim, erected a cathedral church to the south of the imperial chapel for the Divine office of the cathedral chapter.
As in all other Saxon foundations of dioceses, a „structuring" of Hildesheim's young church began rather early: a chapter was assigned to the bishop, which remains his most important advisory body to the present day.

Gunthar (815–834)
Rembert (834–844)

Bishop Ebo

As a result of his position in the conflict regarding the restructuring of the Carolingian Empire, Ebo - who was the archbishop of Reims since 816/817 as well as the papal missionary delegate for Hamburg and Denmark from 823 - had to leave this prestigious bishopric in the Champagne and was named bishop of Hildesheim by King Louis the German four years later.

Ebo (845–851)

852-872 — After three days of prayer and fasting, Bishop Altfrid ordered the construction of a new cathedral to be erected over the imperial chapel and along its western extension. This cathedral was severely damaged by a large fire in 1046.
During the episcopacy of Bishop Altfrid, who was one of the closest advisors to Emperor Louis the German for many years, the important

Altfrid (851-874)
Markward (874–880)

The Architecture – a Chronological Overview

Wigbert (880–903)
Walbert (903–919)
Sehard (919–928)
Dithard (928–954)

monasteries in Lamspringe and Gandersheim were founded in the Hildesheim diocese. Altfrid also erected the Collegiate Church Essen on his own estate in Astnide in which he was later buried.

The veneration of Altfrid began very shortly after his death, especially in Essen; his feast day is on August 16.

Bishop Othwin erected a chapel dedicated to St Epiphanius to the south of Altfrid's cathedral. *c. 963*

Othwin (954–984)
Osdag (985–989)
Gerdag (990–992)

Bishop Othwin returned to Hildesheim from a journey through Italy with Emperor Otto I in 963 with the remains of St Epiphanius of Pavia (died 496), which have been highly venerated relics in the diocese ever since. The reputation of Hildesheim's cathedral school grew steadily during the episcopacy of Bishop Othwin.

Bernward (993–1022)

After *Bishop Bernward* enlarged the episcopal city on the cathedral hill and had it walled in around the year 1000, he began decorating the cathedral with works of art and had the interior walls painted. In addition, the Carolingian west crypt was rebuilt for the bronze doors and a new porch with a stepped main west portal was erected. *c. 1015*

Bishop Bernward is one of the most outstanding personalities who ever occupied Hildesheim's episcopal throne: The diocese Hildesheim advanced to the centre of the Holy Roman Empire during his episcopate and gained enormous importance in religious and political matters. Before being named bishop of Hildesheim, Bernward was court chaplain and tutor of the future emperor Otto III. He retained close contacts to the ruling Ottonian family while serving as bishop.

Among his greatest achievements in Hildesheim itself was the founding of the Benedictine monastery St Michael, where he was later buried. Bernward was canonized in 1193. The veneration of bishop Bernward has remained very lively throughout the centuries. His feast day is November 20.

After Bishop Gotthard erected and decorated a collegiate church over Bishop Othwin's former Epiphanius Chapel immediately to *c. 1035*

The Architecture – a Chronological Overview

the south of Altfrid's cathedral, he had the entire western end of the cathedral torn down. He built a new west front with an atrium surrounded by columns and a new bell tower for a precious carillon. He also had the Bernward doors reinstalled into a smooth wall on the west portal.

Like Bernward, *Bishop Gotthard* was one of Hildesheim's most distinguished bishops. Numerous churches can be traced back to him, and he had a sustained influence on life in the diocese - the clergy as well as the laity.

Godehard (1022–1038)
Dithmar (1038–1044)

Gotthard was canonized in 1131. He was venerated and admired far beyond the boarders of the diocese Hildesheim; countless churches throughout almost all of Europe bear his name.

1046 The cathedral and the city of Hildesheim were destroyed by fire. Only the eastern choir walls and the transept of Altfrid´s cathedral remained standing along with Gotthard's new west front. The eastern choir was provisionally cut off and repaired for the Divine office.

1044-1054 *Bishop Azelin* initiated the construction of a new larger structure to the west of the cathedral. The main choir crypt was relocated to the west beyond Bernward's city wall, the nave extended to Gotthard's still-standing west front.

Azelin (1044–1054)

The Collegiate Church of Sts Simon and Judas in Goslar was consecrated during the episcopate of Bishop Azelin on 2 July 1050. The Hildesheim cathedral scholastic and future bishop of Osnabrück, Benno II (1068-1088), actively participated in its construction.

1061 *Bishop Hezilo* consecrated a new cathedral erected on the foundation walls of Altfrid's cathedral retaining the eastern choir walls and the west front. He abandoned Bishop Azelin's larger cathedral, which remained uncompleted due to massive construction faults. Instead, he kept its nearly completed western transept for use as his residence. The fundamental conflict between the papacy and the empire that took place during Bishop Hezilo's reign culminated in the pilgrimage

Hezilo (1054–1079)

The Architecture – a Chronological Overview

of Emperor Heinrich IV to Pope Gregory VII in Canossa in 1077; a binding reorganization of the relationship between the papacy and the empire was realized in Concordat of Worms in 1122.

Hezilo initiated the reconstruction of the old rotunda in the apex of the eastern choir, but died before the work could be completed.

Construction of the St Lawrence Chapel, which was probably used as a chapter hall. *1079*

Udo (1079-1114)
Bruning (1115–1119)

During his almost 35-year-long episcopate, *Bishop Udo* succeeded in significantly strengthening the episcopal position in Goslar as well as securing the diocese's southern borders (Winzenburg). *c. 1100*

Berthold I. (1119-1130)

Bishop Berthold I encased the eastern apse of the cathedral with new stones and a corble table beneath the eaves.
Bishop Berthold's most significant achievements include the reformation of the monasteries in Riechenberg near Goslar, Steterburg, Heiningen, and Lamspringe. *c. 1120*

 c. 1150

Bernhard I. (1130-1153)

Under *Bishop Bernhard I,* the wooden crossing tower was replaced by a three-tiered stone tower in which the smaller bells of the cathedral's carillon were hung. The two-storied cloister was given the form it still has today. A narrow three-bayed porch was erected in front of the northern transept entrance - the main entrance from the city.
Bishop Bernhard's documents relating to the collegiate churches and monasteries in his diocese provide detailed information about their founding and history. In many regards, the history of the diocese Hildesheim only becomes comprehensible during his tenure.

Bruno (1153-1161)
Hermann (1161–1170)

Bishop Bruno
Bishop Bruno's diverse donations and bequests include, most significantly, his extensive and valuable private library. It contains commentaries on the Holy Scriptures as well as works by historians and philosophers.

The Architecture – a Chronological Overview

Bishop Adelog
The "Great Privilege" of Bishop Adelog from March 28, 1179 fundamentally reorganized the relationship between bishop and chapter, which was, for example, mirrored for centuries in the election capitulations of Hildesheim's bishops.

Bishop Konrad II
Bishop Konrad II, who actively participated in the process of canonizing Elizabeth of Hungary, rendered great services to his diocese by promoting and introducing several religious orders. The Franciscans, for example, came to Hildesheim in 1223/1234 and later to Brunswick and Goslar.

Bishop Siegfried of Querfurt
Siegfried's episcopate is characterized by a continuing conflict with the Guelphs, which resulted in his construction of Gronau castle, the Liebenburg and Ruthe castle. Among his better-known ecclesiastical donations is the Hildesheim "Stift im Schlüsselkorb".

1321 **Bishop Otto of Wohlendberg** erected the St Anne Chapel at the centre of the cloister, which most likely replaced the "capella rotunda". The Thousand-Year-Old Rosebush could only have sprouted at the choir apse after this chapel was torn down.

from 1330 Construction of the Gothic chapels at the side aisles.

Bishop Gerhard vom Berge
The Battle of Dinklar in 1367 represents the low point in the conflict between the Guelphs and Hildesheim's bishops. Its outcome has invariably been described as unexpected and miraculous in Hildesheim historiography: In the end, Bishop Gerhard vom Berge was only victorious because he carried the foundation reliquary, the "Holy Relic of Our Blessed Lady" with him into battle.

Adelog (1171-1190)
Berno (1190–1194)
Konrad I. (1194–1198)
Hartbert (1199–1216)
Siegfried I. (1216–1221)

Konrad II. (1221–1246)
Heinrich I. (1246–1257)
Johann I. (1257–1260)
Otto I. (1260–1279)

Siegfried II. (1279-1310)
Heinrich II. (1310–1318)

Otto II. (1319–1331)
Heinrich III. (1331–1363)
Johann II. (1363–1365)

Gerhard (1365–1398)

The Architecture – a Chronological Overview

Johann III. (1365–1398)

Bishop Johann Count of Hoya

Due to numerous conflicts, the debt of the Prince-Bishopric Hildesheim increased enormously during the episcopacy of Johann III. Nearly all the castles and fortresses in the diocese were pawned at that time.

Magnus (1424–1452)
Bernhard II. (1452–1458)
Ernst I. (1458–1471)
Henning (1471–1481)
Berthold II. (1480–1502)
Erich (1502–1503)
Johan iV. (1504–1527)
Balthasar Merklin (1528–1531)
Otto von Schaumburg (1531–1537)
Valentin von Tetleben (1537–1551)
Friedrich von Holstein (1551–1556)
Burchard von Oberg 1557–1573)

Bishop Magnus Duke of Saxony-Lauenburg

Transferred from the diocese Kammin to Hildesheim, Bishop Magnus saw the restoration of the diocese's external and internal peace as his main task. Johannes Busch and Nicholas of Cusa visited the monasteries of his diocese.

The Chapel of St Lawrence was enlarged to the south with a further aisle. *1440*

The Chapel of St Anthony was built in the extension of the widened Chapel of St Lawrence. *c. 1444*

Construction of the northern paradise and the Chapel of the Patron Saints. *Early fifte century*

Bishop Burchard of Oberg

The sixteenth century was an extraordinarily turbulent time for the diocese Hildesheim due, on the one hand, to the complex political situation, and the Reformation with the ensuing confessional division on the other. The Settlement of Quedlinburg in 1523 divided the Prince-Bishopric Hildesheim among the bishop of Hildesheim and the Guelph dukes: the bishop retained only the administrative centres of Marienburg, Steuerwald and Peine along with the cathedral provost - which meant that the Reformation could gradually also take hold in all other places. In the end, Bishop Burchard's prudent and forceful actions preserved Catholicism in the diocese Hildesheim.

The Architecture – a Chronological Overview

Bishop Ernst of Bavaria

Bishop Ernst of Bavaria was the first of a group of Wittelsbach dukes who served - with the exception of 1688 to 1702 - as the bishops of Hildesheim for almost two hundred years until 1761. This tie to a Catholic ruling family represented a substantial guarantee for the survival of Catholicism in an environment that had turned entirely Protestant since the mid-sixteenth century.

1718–1770 Baroque decoration of the cathedral's interior with stucco and paintings.

Bishop Franz Wilhelm of Westphalia
Bishop Franz Egon of Fürstenberg

Both bishops ruled their diocese in a time of change: the imperial church system of the Ottonian Empire, which had lasted almost 1000 years, had become obsolete due to the confessional division as well as numerous political, economic and social changes. It was the time of a new beginning in which the bishops would focus on their ecclesiastical responsibilities. This period began with the secularisation of 1803/1810: an initially painful transition that quickly turned out to have positive consequences for the diocese Hildesheim.

Bishop Joseph Godehard Osthaus
Bishop Franz Ferdinand Fritz
Bishop Jakob Joseph Wandt

The papal bull "Impensa Romanorum Pontificum" of 1824 redrew the map of the diocese Hildesheim: the new diocese now spanned from the Elbe to the Lower Eichfeld region and from the Weser to the eastern borders of the Kingdom of Hanover and the Duchy of Brunswick. Internal change followed these geographical adjustments: the reorganization of the deanery borders, the reestablishment of the seminary and the restructuring of the Catholic school system.

Ernst II. Herzog von Bayern (1573–1612)
Ferdinand Herzog von Bayern (1612–1650)
Maximilian Heinrich Herzog von Bayern (1650–1688)
Jobst Edmund Freiherr von Brambeck (1688–1702)
Joseph Clemens Herzog von Bayern (1702–1723)
Clemens August Herzog von Bayern (1724–1761)
Friedrich Wilhelm Freiherr von Westphalen (1763–1789)
Franz Egon Freiherr von Fürstenberg (1789–1825)

Joseph Godehard Osthaus (1829-1835)
Franz Ferdinand Fritz 1836-1840)
Jakob Joseph Wandt (1840-1849)

The Architecture – a Chronological Overview

Eduard Jakob Wedekin (1849–1870)
Daniel Wilhelm Sommerwerck (1871–1905)
Dr. Adolf Bertram (1906–1914)
Dr. Joseph Ernst (1915–1929)
Dr. Nikolaus Bares (1929–1933)
Joseph Godehard Machens (1934–1956)
Heinrich Maria Janssen (1957–1982)

Demolition of the west front constructed by Gotthard and the side aisle chapels. New construction of a double tower facade modelled after the Hildesheim St Gotthard Church by the Prussian state architect Wellenkamp.

1841-1850

The diocese Hildesheim developed rapidly during the second half of the nineteenth century. The number of diocesans rose from 65,000 to approximately 210,000. New religious orders and congregations arrived in the diocese and new parishes were founded everywhere - the Catholic Church became present in the Diaspora, initiated and supported by the local Catholics.

Bishop Joseph Godehard Machens
Bishop Heinrich Maria Janssen

Twentieth century

Severe restrictions were placed on the Hildesheim diocese during the National Socialist era: the dictatorial regime attempted to prevent all pastoral and clerical activities, including the gradual abolishment of all Catholic schools. The church of Hildesheim nevertheless remained lively. Men, women, and children participated in its manifold activities, an expression of a firm faith.

March 22, 1945
Bombardment and almost total destruction of the cathedral by fire.

March 22, 1945

March 27, 1960
Re-consecration of the cathedral by Bishop Heinrich Maria Janssen.

March 27, 1960

Dr. Josef Homeyer (1983–2004)
Norbert Trelle (seit 2006)

After the World War II, which almost completely destroyed the diocesan town of Hildesheim and its venerable cathedral, the now almost 700,000 Catholics succeeded in re-establishing or founding countless churches, parish houses, kindergartens, schools, and charitable organisations in the diocese Hildesheim under the guidance of Bishop Machens and Bishop Janssen.

The Architecture – a Chronological Overview

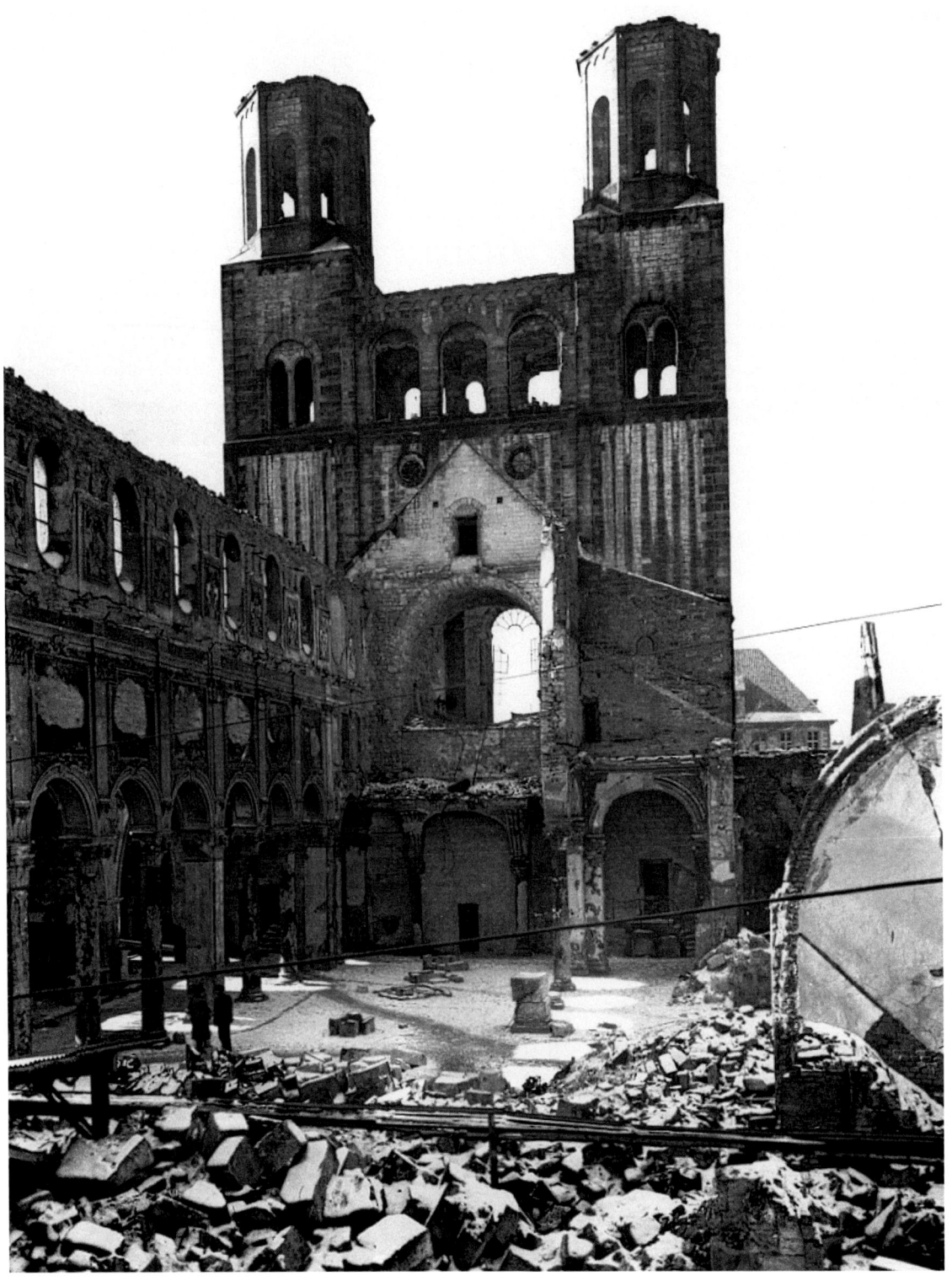

The damaged nave between 1945 and 1948.

HILDESHEIM CATHEDRAL | 21

The Architectural History of Hildesheim Cathedral

KARL BERNHARD KRUSE

The Architectural History of Hildesheim Cathedral

① Stones from the foundation of the Imperial Chapel.

Towards the end of the eleventh century, the author of the „Fundatio Ecclesiae Hildensemensis" chronicled the history of the diocese's origins. He related how the Virgin Mary induced the young emperor Louis the Pious by means of a relic miracle to give up the cathedral church dedicated to St Peter, which his father had begun in Elze and to build a church dedicated to Mary on a hill surrounded by the waters of the Treibe in Hildesheim. This church became the mother church of the new diocese of Hildesheim.

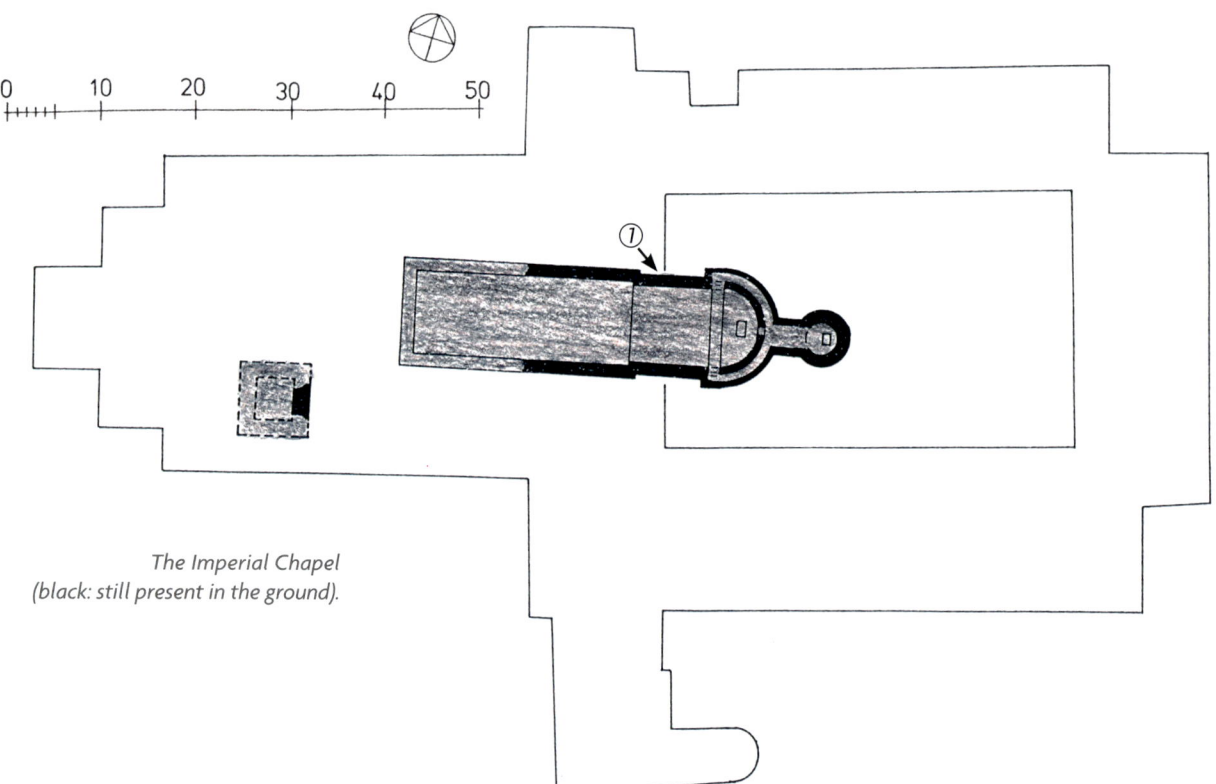

The Imperial Chapel
(black: still present in the ground).

The appearance and dimensions of this church were long unknown. The „Fundatio" only says that its crypt was located under the eastern choir of the cathedral built by Bishop Altfrid and that the bishop

The Architectural History of Hildesheim Cathedral

enlarged the imperial chapel to the west in 852. Excavations of the crypt carried out during a renovation around 1900 did not produce any definitive findings. New conclusions were only reached after the destruction of the cathedral in 1945 in the course of archaeological investigations made in conjunction with the reconstruction. If one takes all of the individual finds documented on the cathedral hill over the past 50 years into consideration, it is possible to reconstruct a fairly accurate picture of this first church in the diocese of Hildesheim, especially as foundation stones and two very large stone blocks from the choir wall are still visible in the access to the heating cellar.

② *Pit in the foundation with a burial.*

As there were no trained stonemasons or bricklayers in the diocese of Hildesheim during the time of Louis the Pious, experienced construction workers had to be recruited from the southern and

The first Hildesheim Cathedral.

The Architectural History of Hildesheim Cathedral

Detail of the Cathedral apse with the Foundation Reliquary.

western regions of the empire to build a large stable stone structure. As there were no trained stonemasons or bricklayers in the diocese of Hildesheim during the time of Louis the Pious, experienced construction workers had to be recruited from the southern and western regions of the empire to build a large stable stone structure. The quality of the still existing floor and wall brickwork of the crypt indicate that this is what happened and that an attractive single-nave church with a choir apse, a drawn in choir bay and perhaps also a lowered nave was swiftly built. The relics of the Virgin Mary brought from the imperial chapel in Aachen were kept in the very small chapel at the apex of choir that Bishop Altfrid later integrated into his ambulatory chapel and exhibited for veneration on major feast days.

Christianisation seems to have proceeded at a rapid pace and the veneration of the Virgin among the populace was apparently so far-reaching that the first bishop, Gunthar, realized the necessity of building a larger first cathedral to the south of the imperial chapel for the divine offices and liturgy of the cathedral chapter as early as 820, only a few years after the diocese was founded. This was dedicated to St Cecilia. Several remnants of its foundation have also been excavated in the present-day schoolyard of the Josephinum as well as in St Anthony's Church in the cloister and in the area of the cathedral sacristy. They demonstrate that this church was not, as had been earlier assumed, made of wood. In addition, the two high towers mentioned in the „Fundatio", the remnants of which were still visible during the eleventh century, also seem to indicate a spacious cathedral according to the fashion of the first half of the ninth century. If one takes all the known excavated finds as well as the largest conceivable dimensions of the excavated Carolingian fortifications and the already existing imperial chapel in the north into consideration, it is possible to cautiously reconstruct a hypothetical church with a three-aisled nave, a choir apse, a larger transept in the west and two towers. More precise will perhaps be garnered from archaeological investigations to be carried out during a planned restoration of the cathedral.

The Architectural History of Hildesheim Cathedral

Cathedral of Bishop Altfrid.

Altfrid became bishop of Hildesheim in 852. The St Cecilia Cathedral was too small for him and he wanted to further enhance the reverence for the Virgin initiated by Emperor Louis the Pious. After three days of prayer and fasting, the Virgin showed him the appearance and dimensions of the new cathedral. Bishop Altfrid built a new choir with an apse over the choir of the imperial chapel. It was possible to enter an ambulatory crypt with two smaller asides and the integrated older chapel in the apex of the choir from the choir by means of the continuous crossing and the two still-existing portals. Two secured chambers, which were only accessible from the choir and which possibly had stairs leading to the choir ambulatory, were located in the corners between the transept and the crossing. The ambulatory around the choir apse was probably only one-storied to allow the choir to be illuminated by windows. The findings do not

③ *Nothern entrance to the ambulatory crypt with remnants of the stucco tympanum.*

The Architectural History of Hildesheim Cathedral

④ *Glass tessera, tenth century.*

Bishop Othwin's Epiphanius Chapel.

provide information about the appearance of the room under the choir crossing. However, it was probably not entirely filled with earth because the exterior walls were too weak.

A three-aisled nave was attached to the continuous transept that was separated from lower side aisles by a row of columns that was broken up by a pillar in the middle. There was also a choir in the west located above a west crypt. There was as yet no a central west portal; one probably entered the aisles via side portals. The excavated foundations allow us to reconstruct a higher as well as a wider middle west tower over the west crypt and the west choir in addition to two smaller west towers.

The cathedral encompassing a richly structured east front and postulated west towers erected by Bishop Altfrid and consecrated in 872 stood in a walled-in cathedral fortification on a hill near the Innerste surrounded by the waters of the Treibe. The significant east-west long distance trade route passed through the nearby marketplace. Within the confines of the fortified city, it has only been possible to

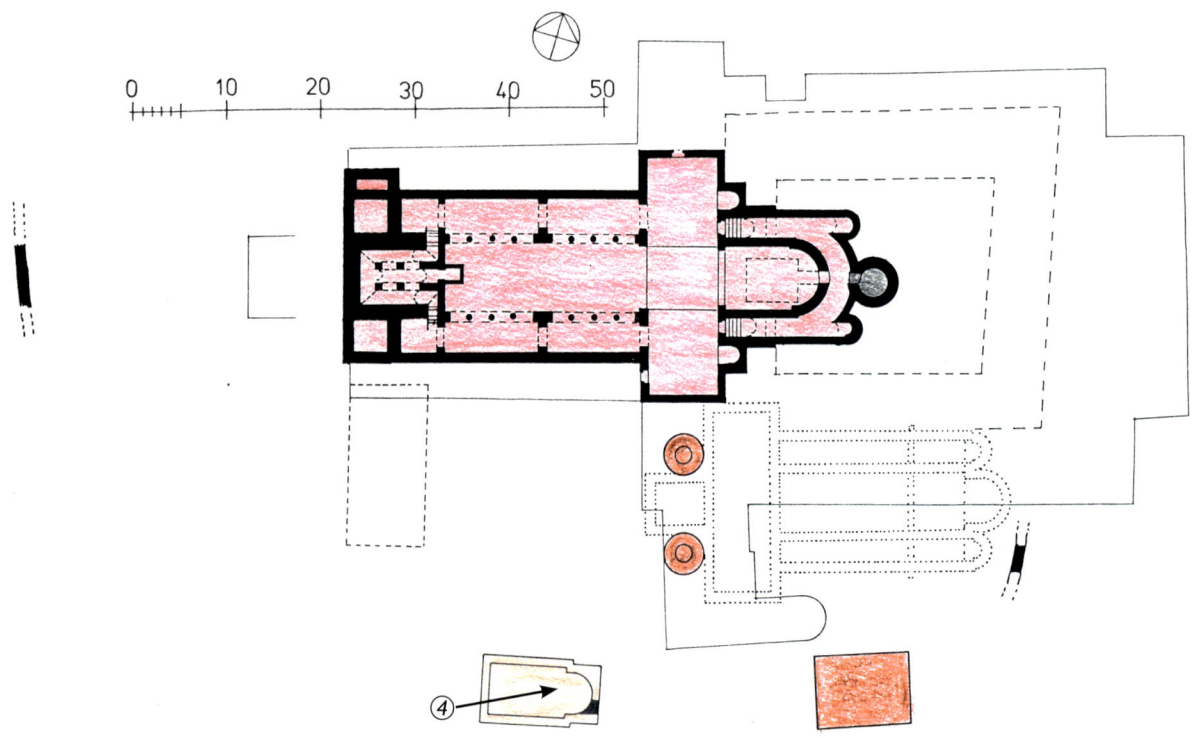

The Architectural History of Hildesheim Cathedral

excavate the first cathedral erected by Bishop Gunthar and a stone building erected in the immediate vicinity, which I interpret as a bishop's residence. The cathedral clerics probably still lived together in the enclosure around the cloister that was later substituted by the two-storied twelfth century structure. The living quarters of the merchants and artisans in the city outside the protective wall were built of wood.

In November 962, Bishop Othwin of Hildesheim, who was returning from the coronation of Emperor Otto III in Rome, was able to come into possession of the relics of St Epiphanius and secretly sent them across the Alps to Hildesheim. As there were no „undivided relics" of a saint in Hildesheim until then, this saint was ceremoniously placed in the cathedral amidst the widespread participation of the populace. As it would not have been possible to build a new west crypt during the brief winter months, the existing west crypt was therefore probably used for them.

Bishop Bernward decorated the Cathedral and installed the bronzes doors. The walled-in Cathedral hill.

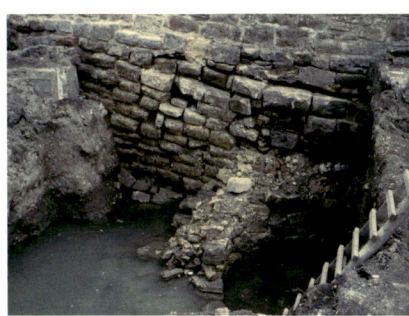

The Bernwardian wall with the foundations of round towers.

HILDESHEIM CATHEDRAL | 27

Statue of St Bernward by Karl Ferdinand Harzer in the Cathedral courtyard.

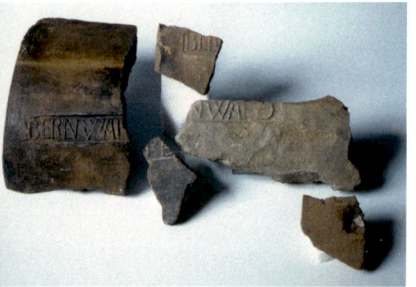

Bernwardian bricks inscribed with his name.

Newly fired Bernwardian bricks showing the pattern in which they were laid.

In 1998, it was possible to excavate the eastern apse of a chapel in the present-day schoolyard of the Josephinum just south of the cathedral. Due to the location, the stratigraphy and the later larger church built over it, it was probably Bishop Othwin's chapel.

When Bernward was consecrated bishop in 993, he first had to deal with the internal and external security of his diocese. Aside from fortifying the diocese's borders, he walled-in the entire cathedral hill and enlarged the fortified „city" to such an extent that the merchants and artisans had to move north to the vicinity of St Andrew's Church, which he founded. The east-west long distance trade route now ran over the cathedral hill through the two still-standing city gates.

He had the cathedral itself richly decorated. Bernward hung the first large chandelier and the walls were lavishly painted. Because he devoted all of his attention to the Benedictine monastery St Michael's, which he founded and intended as the site of his tomb, the exterior form of the Alfrid cathedral was kept. According to the donation inscription, he cast the two bronze doors with scenes in three-quarter relief from the Old and New Testaments in 1015. In all probability, he had them installed in the new porch on the west front of the cathedral. His reconstruction of the west crypt is certain. It was shortened by one bay to provide enough space for the erection of a small porch and a west front with a starkly deepened portal niche. It is not known if these tasks were actually completed. It was still not possible for the bishop to ceremoniously enter the cathedral past the bronze doors without taking a roundabout route because the west crypt and the choir above it hindered this. The most recent excavations in St Michael's carried out in conjunction with its reconstruction show that the bronze doors could not have come from there as was longed assumed. There was no space for these gigantic doors in St Michael's exterior walls. The west crypt was also certainly a part of Bishop Bernward's plans for this monastery church; there was never any previous construction or earlier entrance hall under the west crypt.

Gotthard, who was almost the same age as Bernward, became bishop after the latter's death in November 1022 and served for the

The Architectural History of Hildesheim Cathedral

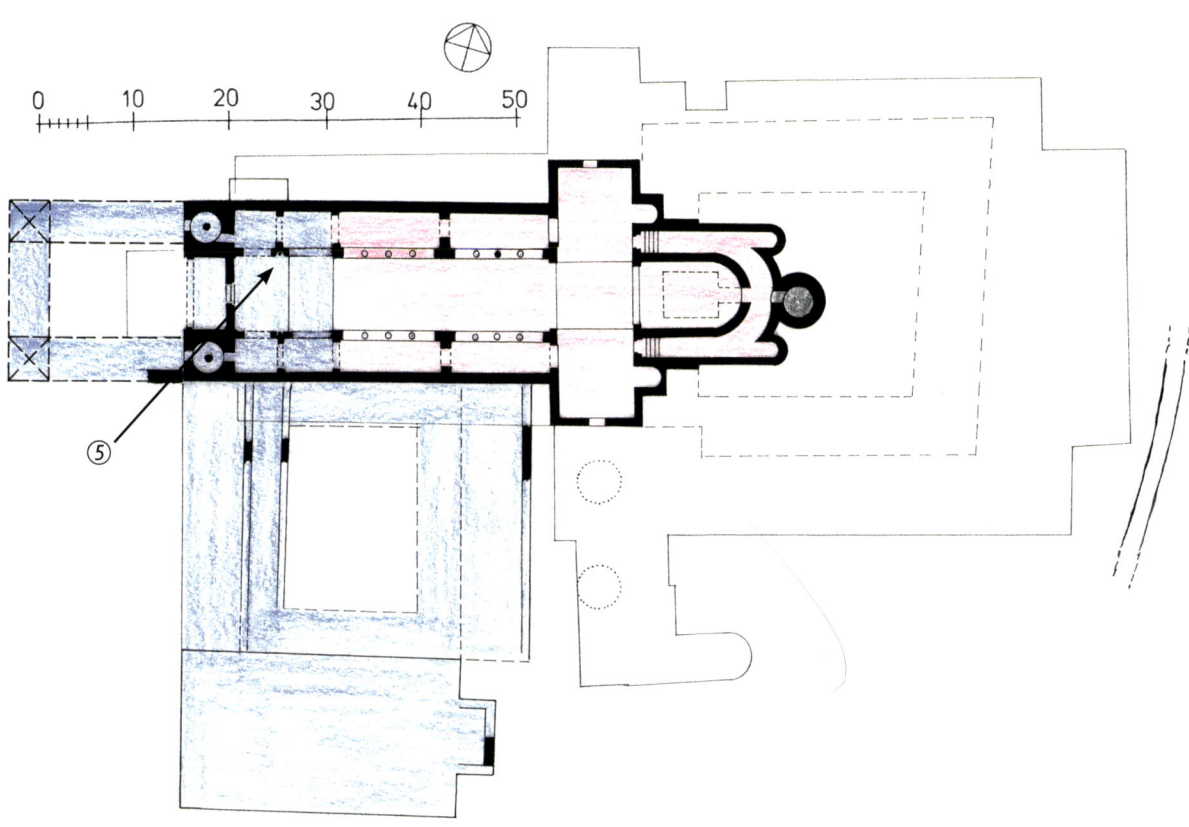

next 16 years in this position. He intended to bolster ecclesiastical clerical life in the cathedral precinct and built at the outset a new collegiate church just south of the cathedral. To this end, he had to tear down the freestanding Chapel of St Epiphanius. The collegiate church was consecrated as early as 1026 and was occupied by clerics who led a model communal spiritual life here.

The biography of Bishop Gotthard informs us that he had the crypt that „darkened" the western section of Altfrid's cathedral torn down entirely. At the same time, all other sections at the west end of the cathedral including Bishop Bernward's still uncompleted western entry porch with the bronze doors were probably also demolished. At the west end of the nave Gotthard built a high, two-storied structured room in the side walls, in the centre of which the side walls of the buttresses with the attached columns and capitals containing

The Bishop Gotthard's Collegiate Church and west front.

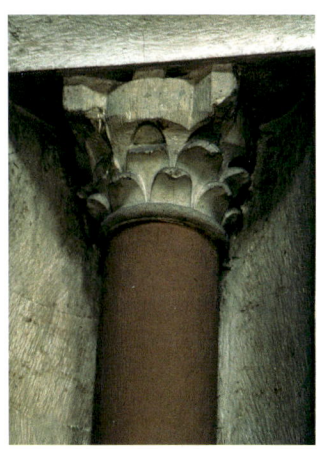

⑤ *Attached column with leaf-shaped ornaments on the capital c. 1035.*

The Architectural History of Hildesheim Cathedral

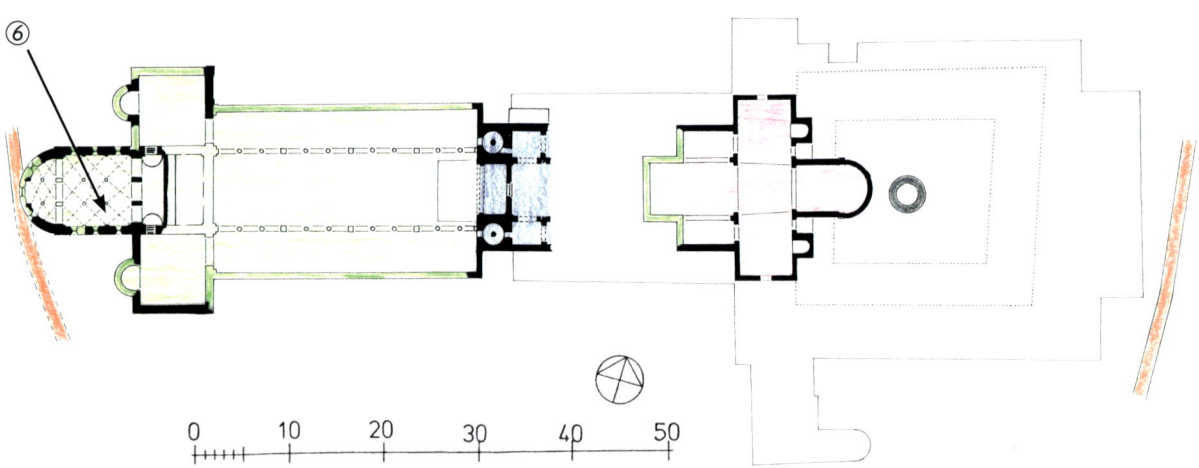

The burning of the Cathedral in 1046 and the new construction by Bishop Azelin the west.

⑥ *The preserved walls of the crypt from the Cathedral of Bishop Azelin; the original entry arches at the left.*

leaf-shaped ornaments stood. The newly created chapels at the side aisles were each opened to the nave with a large rounded arch in which a column also stood. Towards the west, there was also a similar arch with attached columns that opened a tower chapel to the nave. Gotthard had Bishop Bernward's bronze doors installed in a smooth wall below this opening. A porch was attached to the westfront, over which the high bell tower stood. The paradise with columns and further towers known from written sources was probably attached to it at the west. The brickwork of this west front, which was completed in 1035, as well as the bronze doors, survived the fire of 1046 without damage. Gotthard's west front thus stood until the mid-nineteenth century, when it was torn down. The original doorframes withstood the damages of the war and remained standing until 1955.

On Palm Sunday, 23 March 1046, a fire stemming from one of the fireplaces of the cathedral canons broke out that engulfed the cathedral as well as Gotthard's collegiate church and its enclosures in addition to widespread parts of the city. Even a storage building for grain located to the southwest at the Bernward wall fell victim to the flames. Bishop Azelin, who had been bishop in Hildesheim for about a year, did not immediately have the cathedral repaired, although contemporaries report that this would have been possible. Instead, he had the choir repaired in a makeshift manner. In addition, he had the nave torn down entirely and began with the construction

The Architectural History of Hildesheim Cathedral

of a new three-aisled basilica to the west of Gotthard's west front. The main choir with the choir crypt and the access from the transept, which were now located in the west, was even built over Bernward's city walls. However, this new construction was ill fated from the very beginning. The walls as well as the already erected columns soon came out of sorts due to the soft and clayey subsoil and had to be constantly repaired. The new construction was given up when Azelin unexpectedly died in 1054. The almost completed transept was, however, transformed into a bishop's palace that has been in use since the times of Bishop Hezilo.

In the year of his consecration as Bishop of Hildesheim, Hezilo had the work on Azelin's cathedral ended. Hezilo's own cathedral construction, which was completed by 1061, utilized the still-existing foundation of Altfrid's cathedral as well as the walls of the eastern choir and the west end of Bishop Gotthard's cathedral. The ambulatory

⑦ *The last original eaves from the Cathedral of Bishop Azelin.*

The Romanesque Cathedral of Bishop Hezilo.

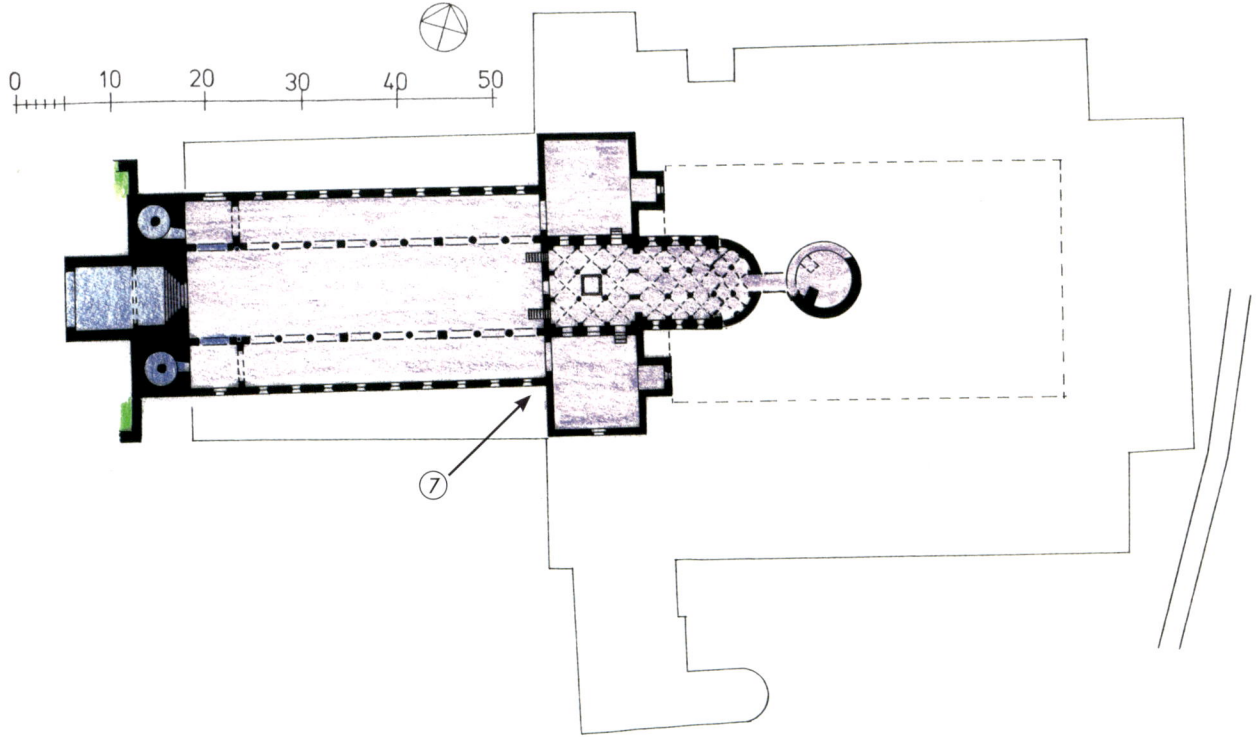

The Architectural History of Hildesheim Cathedral

crypt and the chapel at the apex were not rebuilt. He instead added a new crypt under the now detached crossing and connected it to the older choir crypt creating a large space with a nave and two aisles in which the old Altar of the Blessed Virgin now found its place. The new high altar now stood above the Altar of the Virgin in the raised choir in front of the apse. The Lower Saxon alternating supports in the nave were modelled after St Michael's Church. The West Paradise in front of the bronze doors was now stepped.

Bishop Hezilo's three-aisled Romanesque basilica was hardly larger than Altfrid's Carolingian cathedral. Its upward proportions had grown somewhat and the new design of the eastern choir no longer allowed for the internment of the bishops in the choir. The tomb of Bishop Gotthard, who died in 1038, which still stood at ground level in the choir bay and attracted countless visitors because of the miracles that had occurred here, was to be moved to the new crossing crypt. The central vault field was left open to provide the

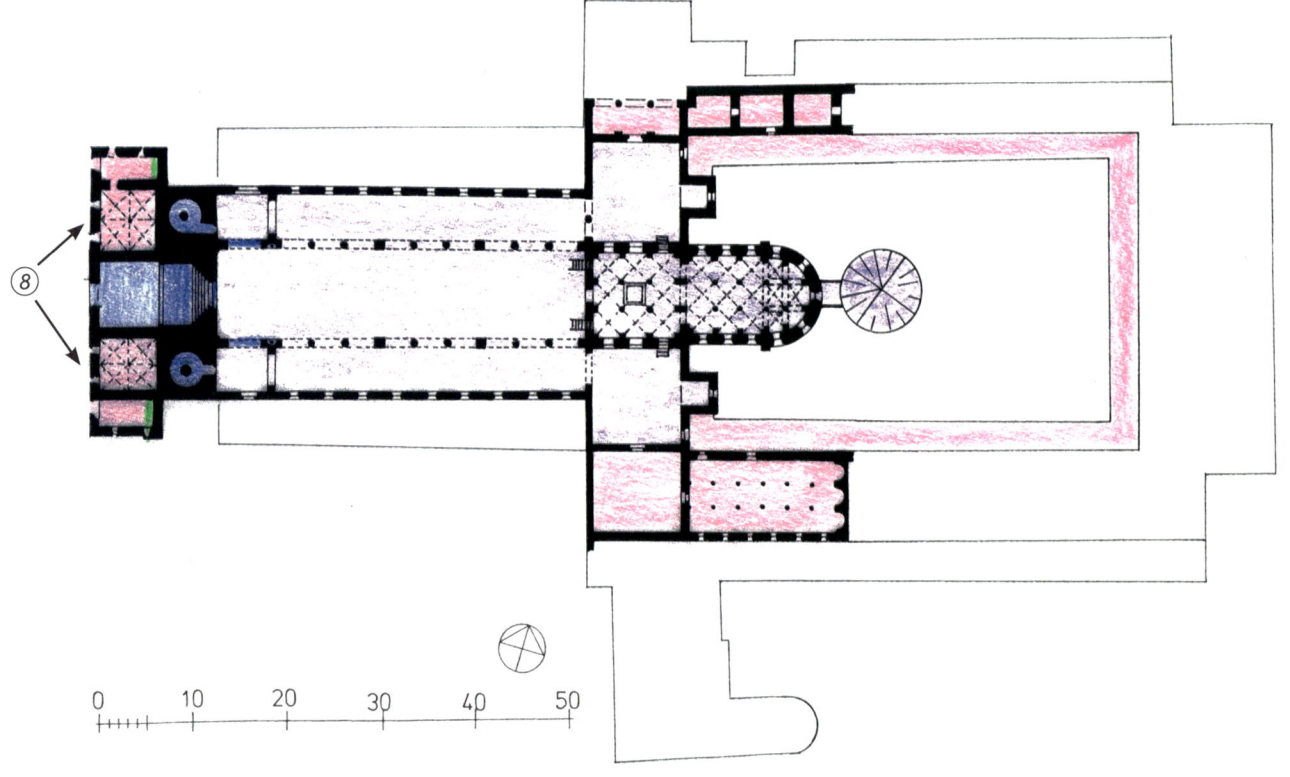

The chapels added during the twelfth and thirteenth centuries.

cathedral canons in the raised choir with a direct view of the tomb. It was also possible to lead the pilgrims to the tomb in the crossing crypt in an orderly fashion via the various doors in the west as well as in the north and south wall. The choir crypt was reserved for the Altar of the Virgin. There was probably also a wooden tower above the crossing during Hezilo's times. It was replaced by the three-tiered, stone crossing tower with bells still known from illustrations made during the twelfth century. Shortly before his death, Hezilo had the old former chapel at apex of the apse in the cloister slightly enlarged and connected it to the crypt. However, he died in 1079 before the reconstruction could be completed.

During the twelfth century, the still-existing, two-storied cloister was built along with the auxiliary buildings for the cathedral school and the dormitories for the cathedral canons, who were required to be present here before certain liturgical ceremonies in the cathedral. During the first half of the twelfth century, Bishop Bernhard had the eastern apse enclosed in a new casing, which, like the contemporaneous St Gotthard's Church, was decorated with flat half columns, and an arched frieze under the eaves. The direct connection between the crypt and the circular chapel was probably closed at this time.

Two chapels were erected adjacent the west paradise, Sts Simon and Judas in the north and St Bernward in the south. Living spaces were built for the bell ringer and the sexton above them. A separate chapel for the bishop was also located in the upper area next to the west tower on the south side that was probably directly linked to the small bishop's residence. A vaulted paradise stood in front of the northern entrance to the transept and the sacristy was built onto the south side. The first chapel in the cloister, the vaulted St Lawrence Chapel with a nave and two aisles was built directly adjacent to the sacristy and probably also served as the first chapter hall.

In 1321, Bishop Otto I had a small chapel dedicated to St Anne build on the Anne Cemetery directly to the east of the then still-standing or already demolished circular chapel. It was the first pure

⑧ *Capital from the Chapel of Simon and Judas.*

The Architectural History of Hildesheim Cathedral

The Gothic chapels.

⑨ The North Paradise.

Gothic structure in Hildesheim. The circular chapel was probably relinquished when this chapel was completed at the very latest. This left space for the „1000-year old rosebush" on the apex of the cathedral's eastern choir.

During the fourteenth and fifteenth centuries, when Romanesque churches were being torn down or completely rebuilt in other cities, the authorities in Hildesheim were content to build a series of individual gothic chapels along the aisles. They had been built by patrons since 1330 after breaking through the northern and southern exterior walls and furnished with altars.

The cathedral cellarer Lippold von Steinberg built a new two-storied North Paradise during the early fourteenth century, which is still serves as the representative entrance to the cathedral from the city. Sandstone sculptures of the Virgin and Sts. Bernward and Gotthard were added to the gothic facade. The St Lawrence Chapel was extended to the south by a further aisle and used as a chapel. The meetings of the cathedral chapter took place in the newly constructed gothic chapter house to the south of the sacristy since

the late thirteenth century. A very large hypocaust heating system in the basement-like ground floor provided sufficient warmth. In the extension of the broadened St Lawrence Chapel, the likewise vaulted but lower St Anthony Chapel was built around 1444. A dormitory was located on the top floor, accessible from the upper cloister. The attics were rebuilt to serve as grain storages.

During the Reformation, the cathedral remained almost entirely reserved for Catholic services for the canons and the residents of the cathedral precinct. While the rule over the city and the cathedral precinct changed hands several times during the Thirty Years War, no architectural changes were made.

Prince Bishop Josef Clemens was the first to implement Baroque decorations in the cathedral by way of painting and ornamental plasterwork in the crossing carried out in 1718. Prince Bishop Clemens August, the Duke of Bavaria and simultaneously Prince Bishop of Cologne, completed the work that was carried out by the plasterers Michael Caminada and Carlo Rossi. The ceiling painting was made by Carlo Bernadini from Mannheim. The Baroque redecoration of the crypt was realised under Prince Bishop Friedrich Wilhelm of Westphalia. Around 1720, the dilapidated stone crossing tower with the dome that was gilded after the victory of Bishop Gerhard vom Berge over Duke Magnus the Elder of Brunswick at Dinklar in 1367 was torn down and replaced by a wooden Baroque tower. The top section of the dome was likewise gilded to serve as a symbol.

The damages to the west tower that had occurred since the eighteenth century were mended in a makeshift manner and no repairs at all were made after the start of the nineteenth century, when responsibility for the maintenance of the cathedral was assumed by the state. When the damages became so severe around 1840 that immediate steps were necessary, the area in front of the west tower was closed off, but no repairs were carried out. Instead, the responsible building site manager Wellenkamp had the crack opened so that more water could seep in. His intention was to have the tower torn down completely so that an entirely new double

Interior of the Cathedral with the Irmin's Column, the Chandelier of Bishop Hezilo and the choir screen (c. 1900).

The Architectural History of Hildesheim Cathedral

Demolition and reconstruction of the west front between 1842 and 1850.

⑩ *Cathedral seen from the south (c. 1900).*

tower could be built after the model of St Gotthard. He succeeded in this and the double tower facade was completed in 1850. The crypt was restored in a historicized Romanesque style towards the end of the century. However, excavations attempting to find the first chapel of Louis the Pious remained unsuccessful.

During World War II, important monuments from Hildesheim Cathedral were evacuated and the bronze doors were bricked up. Hildesheim and the Cathedral escaped the bombardments with comparatively little damage until the spring of 1945. With the exception of a few streets, the city of Hildesheim was so severely damaged by bombs on 22 March 1945 - only about two weeks before the Americans marched into Hildesheim in early April 1945 - that the entire old town with its timber-framed buildings burnt. The cathedral was hit by so many high-explosive bombs and incendiary devices that the entire north side, the transept, and the eastern choir collapsed. The still-existing roofs and the west tower were completely destroyed by the fire because nobody was there to extinguish it. Further still-standing sections of the building collapsed during the following

The Architectural History of Hildesheim Cathedral

■ well preserved ▨ heavily damaged ☐ completely damaged
▩ partially preserved ▦ buried

0 10 20 30 40 50

years because the site was not protected and because of the ongoing dispute after the war about whether the state, which was responsible for the structure, would have to rebuild the cathedral at all.

The art student Josef Boland took advantage of the time before reconstruction work began to excavate in the ruins. The discovery of the Carolingian ambulatory crypt, the apex chapels, and the previously unknown sections in the west as well as the recognition that the eastern transept along with the lower sections of the choir walls belonged to the Carolingian cathedral erected by Bishop Altfrid had several effects. The Bishop and the cathedral chapter developed the wish to leave the cathedral as Carolingian as possible, but also to rebuilt it as large as possible in order to provide a new home in the Hildesheim Cathedral for the many Catholic refugees from the east, mainly from Silesia. The competition was won by the Hannover

The war-damaged Cathedral, 1945.

HILDESHEIM CATHEDRAL | 37

The Architectural History of Hildesheim Cathedral

The reconstruction to 1960.

architect W. Fricke, who, as opposed to his competitors, did not alter the basic measurements of the Romanesque cathedral. However, the reconstruction dragged on due to the above-mentioned litigation as well the lack of funds and the death of Bishop Joseph Godehard Machens.

It was Heinrich Maria Janssen, who became Bishop of Hildesheim in 1958, who was able to preside over the re-consecration the cathedral on 14 May 1960. The exterior was relatively faithfully reconstructed on the foundation of Bishop Hezilo's cathedral. Inside, however, changes - especially in the eastern choir and in the west - were made in anticipation of the liturgical reform implemented by Vatican Council starting in 1962. The choir, which was for all extensive purposes previously cut off by the choir stalls and the Renaissance choir screen forming a church within the church, was transformed into a large choir opening up to the nave. Dispensing with a cross altar, the high altar, which had stood in front of the apex of the apse since 1061, was now placed in front of the crossing in the choir bay at the spot where the opening to Gotthard's tomb in the crypt was

The Architectural History of Hildesheim Cathedral

located. The shrine of the cathedral's patron saints with the relics of St Epiphanius was placed behind glass beneath the top slab of the large freestanding altar. Bishop Hezilo's chandelier, which had hung for almost 900 years in the middle of the nave, was now positioned above the altar. In accordance with the taste of the late 1950s, the Baroque sandstone floor was replaced by a precious marble surface.

All surviving Baroque ornamental plasterworks and paintings were relinquished in favour of a unified white coat of paint and the still-existing or salvaged works of art were arranged in a museum-like fashion in the empty side chapels. The intentional modesty of a diaspora bishopric - which had taken in twice as many Catholics as had lived here before the war and was now required to care for the new churches in the state - determined the appearance of today's cathedral that arose on the foundation walls of Bishop Hezilo's Romanesque cathedral - shows the effects of the thrifty spirit of the new start during the post-war years. A planned renovation intends to reverse or reduce the most serious intrusions in the cathedral's substance by the time of the diocese's and cathedral's 1200th anniversary in accordance with the liturgical requirements of the twenty-first century suitable to its importance as a part of the world's cultural heritage.

The crossing, c. 1960.

HILDESHEIM CATHEDRAL | 39

View from the upper cloister at the Cathedral apse with the Thousand-Year-Old Rosebush.

Northwest portal of the Cathedral with the foundation stone of the reconstruction.

HILDESHEIM CATHEDRAL | 41

Interior of the Cathedral View through the nave to the east.

Shrine of the Cathedral's Patron Saints, the so-called Epiphanius Shrine, Hildesheim, third/fourth decades twelfth century.

Bronze Eagle lectern, c. 1220/30.

Chandelier of Bishop Hezilo, c. 1061.

So-called „Inkpot Madonna", c. 1400.

▬ *Light column, so-called "Irmin's Column", eleventh century, Madonna by Paul Jobst Syri 1741.*

Bronze Baptismal Font of Wilbernus in the Chapel of St George, c. 1225.

Bernward Doors, 1015.

HILDESHEIM CATHEDRAL | 49

Maria from the Altar of the Immaculate Conception, Paul Egell 1729-11.

St Joachim from the Altar of the Immaculate Conception, Paul Egell 1729-11.

St Anne from the Altar of the Immaculate Conception, Paul Egell 1729-11.

52 | HILDESHEIM CATHEDRAL

Madonna of Mercy from the Altar of the Virgin in the crypt, last third fourteenth century.

Column of Christ, c. 1025.

Column of Christ, detail.

■ *The Holy Sacraments picture of the Cathedral Canon Ernst von Wrisberg, c 1585.*

56 | HILDESHEIM CATHEDRAL

Shrine of St Gotthard, Hildesheim, third/fourth decades twelfth century.

Cross from the tabernacle in the crypt, Lioba Munz, c. 1960.

Foundation Reliquary (Holy Relic of Our Lady), silver capsule, early ninth century.

Precious Gospels of St Bernward, dedication image, 1015.

Precious Gospels of St Bernward, dedication picture, 1015.

Large Golden Virgin, c. 1000.

62 | HILDESHEIM CATHEDRAL

Stone floor from the choir apse, detail, Hildesheim, c. 1160.

Flagellum, Hildesheim, 1st half twelfth century.

64 | HILDESHEIM CATHEDRAL

So-called Gotthard Staff, 2nd quarter twelfth century.

Head Reliquary of St Oswald, Hildesheim, c. 1185-89.

Large Golden Chalice of Bishop Gerhard, so-called Bernward Chalice, Hildesheim, c. 1400.

Tapestry from the „Rittersaal", The State Council, François de la Planche, Paris, c. 1615.

Tapestry from the „Rittersaal", The Judges receiving the Petition, François de la Planche, Paris, c. 1615.

HILDESHEIM CATHEDRAL | 69

Joachim and Anne, alabaster relief from the former cathedral high altar, Hildesheim, 1625.

Cathedral apse with the Thousand-Year-Old Rosebush.

Interior of the Chapel of St Anne, 1321.

Chandelier of Bishop Thietmar (so-called Azelin Chandelier), eleventh and fifteenth centuries.

Choir screen from the Cathedral, now in St. Anthony's, before 1546, Westphalian workshop.

74 | HILDESHEIM CATHEDRAL

Tombstone of Bruno the Priest, southern exterior wall of the choir, c 1200.

HILDESHEIM CATHEDRAL | 75

Photo credits

Dom-Museum: page 4 top/below, 5, 6 , 7, 8, 9, 10, 11, 12, 24, 28 middle, 29, 30, 33, 35, 36, 39 below, 42, 43, 44, 45, 46, 47, 48, 49, 50, 51, 52, 53, 54, 55, 56, 57, 58, 59, 60, 61, 62, 63, 64, 65, 66, 67, 68, 69, 70, 72, 73, 74, 75, Rückseite

Verlag Schnell & Steiner: page 34, 71

Andreas Hartmann: Titelfoto, page 4 middle, 28 top, 40, 41

Bernward Medien GmbH: page 1, 2, 3,

Wehmeyer: page 21, 37, 39 top

Karl Bernhard Kruse: page 22, 23, 25, 26, 27, 28 below, 31,